Meeting a Dream

by John Angiulo

Copyright© 2013 by John Angiulo

All Rights Reserved

ISBN-13: 978-1493636068
ISBN-10: 1493636065

Dedicated to Strangers

for the Infinite Possibilities you represent

and for an unspoken, invisible Truth

which we all Share

and that you reminded me of.

One morning, as the sun was just rising,
a woman walked down a street on her way to work.

A lone man stood on the corner
looking at the sunrise.

As she was about to walk past him

he turned to her and said,

"Hey, I Know You."

She looked him up and down
then shook her head and said,

"No. We've never met before.
You must have me
confused with
someone else."

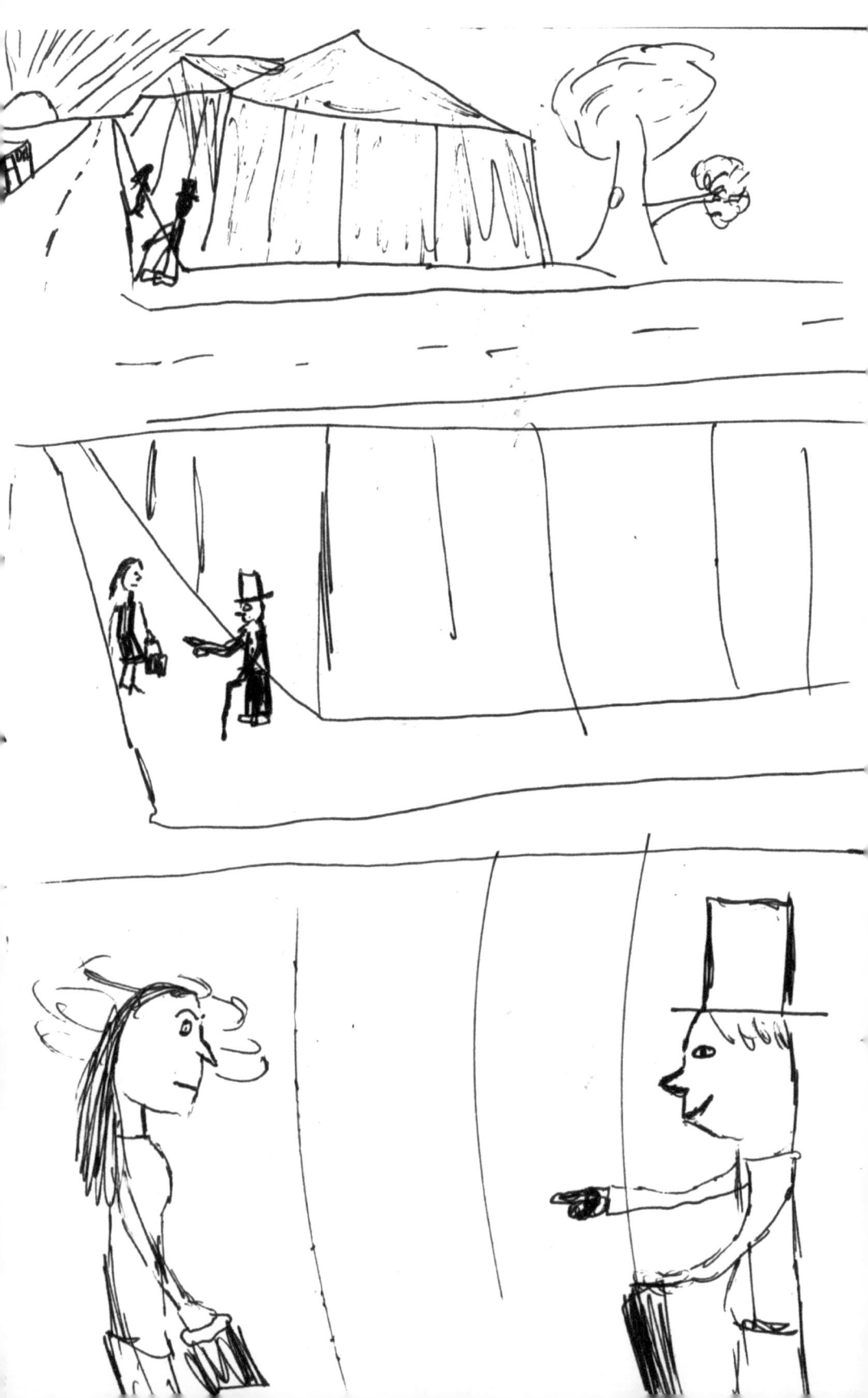

He smiled again and answered,

"Yes, we have met... in a Dream...

A Dream we made together."

"I'm sorry sir. But we don't know each other.
We have met Never.

And besides, I haven't had a dream
in close to forever."

"Ah! But the Dream happened before forever.

And you even told me that you wouldn't remember.

You told me you'd be a lady

and we would meet

someday in September."

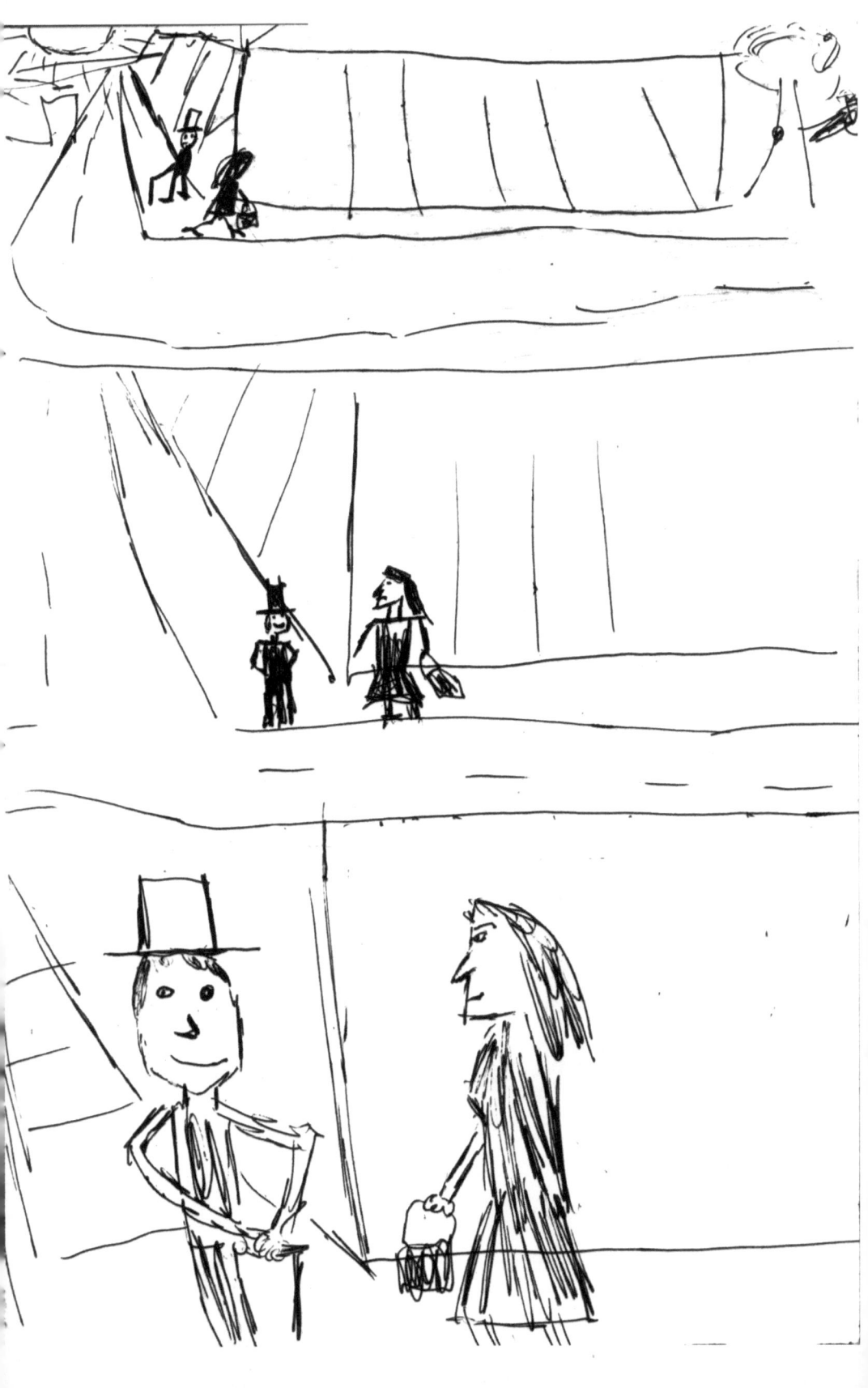

"Come and sit by this tree with me.

Let's see if we
 can set that memory of yours free."

And she answered,

 "Okay, but just for a minute.

 I don't have all day."

" You have more than all day.

All day I say, to stay and to play!

 And our Dream started

 in just such a way...

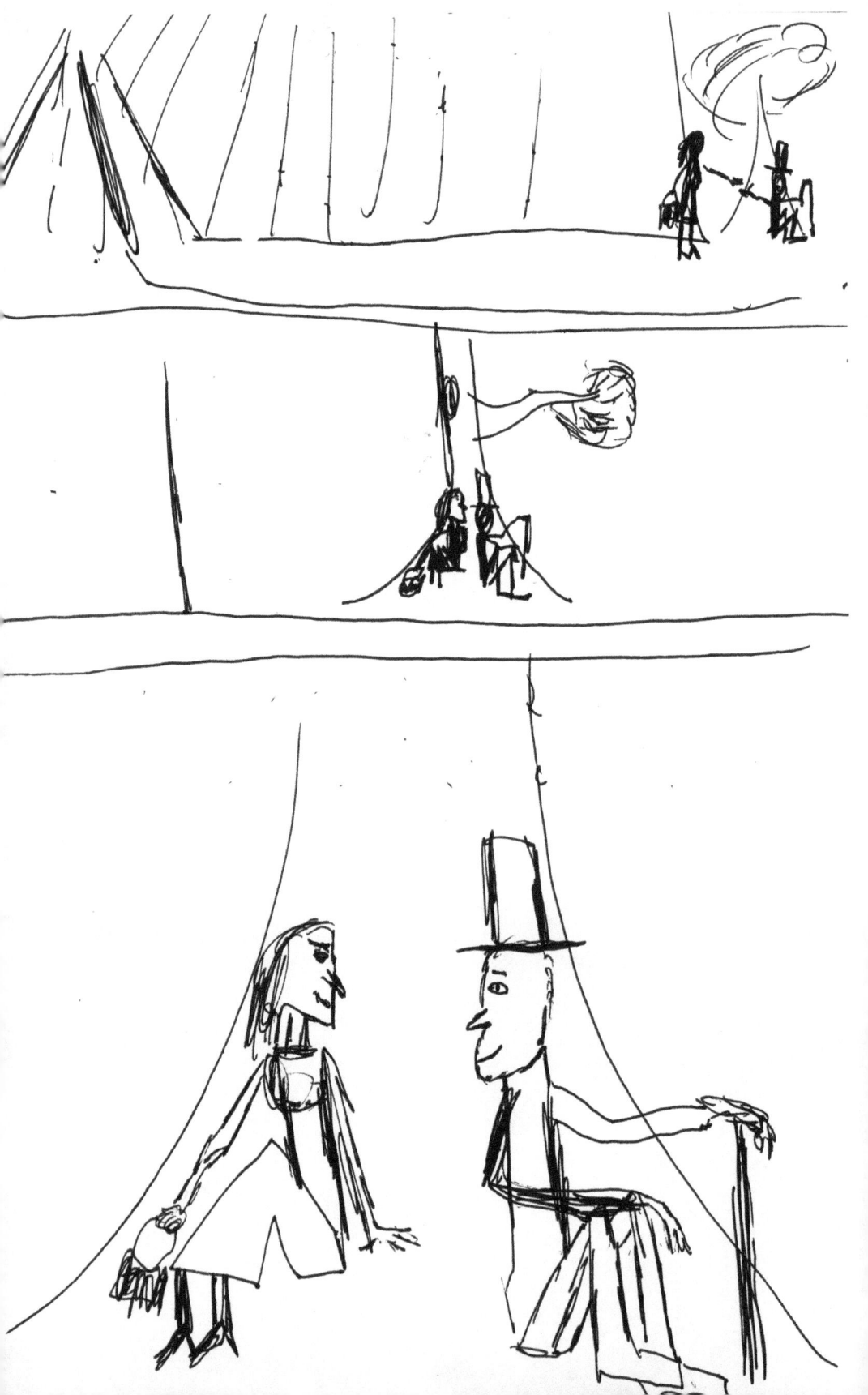

through the Air shrouds.

And then there You were

lassoing a Planet

that had been flying through Space.

You went speeding by

so wild and Free

it was plain to Me

that I had to Give chase.

I followed you through two Galaxies

and a Black Hole.

I followed you over a Cosmic Bridge...

and I paid the toll.

And when I finally caught up

 you were laughing with Glee.

You said, "No one has ever lasted so long

 chasing after Me."

Then we became Friends

 some of the best

and Created through all Imagination

 on a Cosmic Quest.

You and I turned into Fish

And swam through the Sky.

Then became Birds

and flew through the Sea

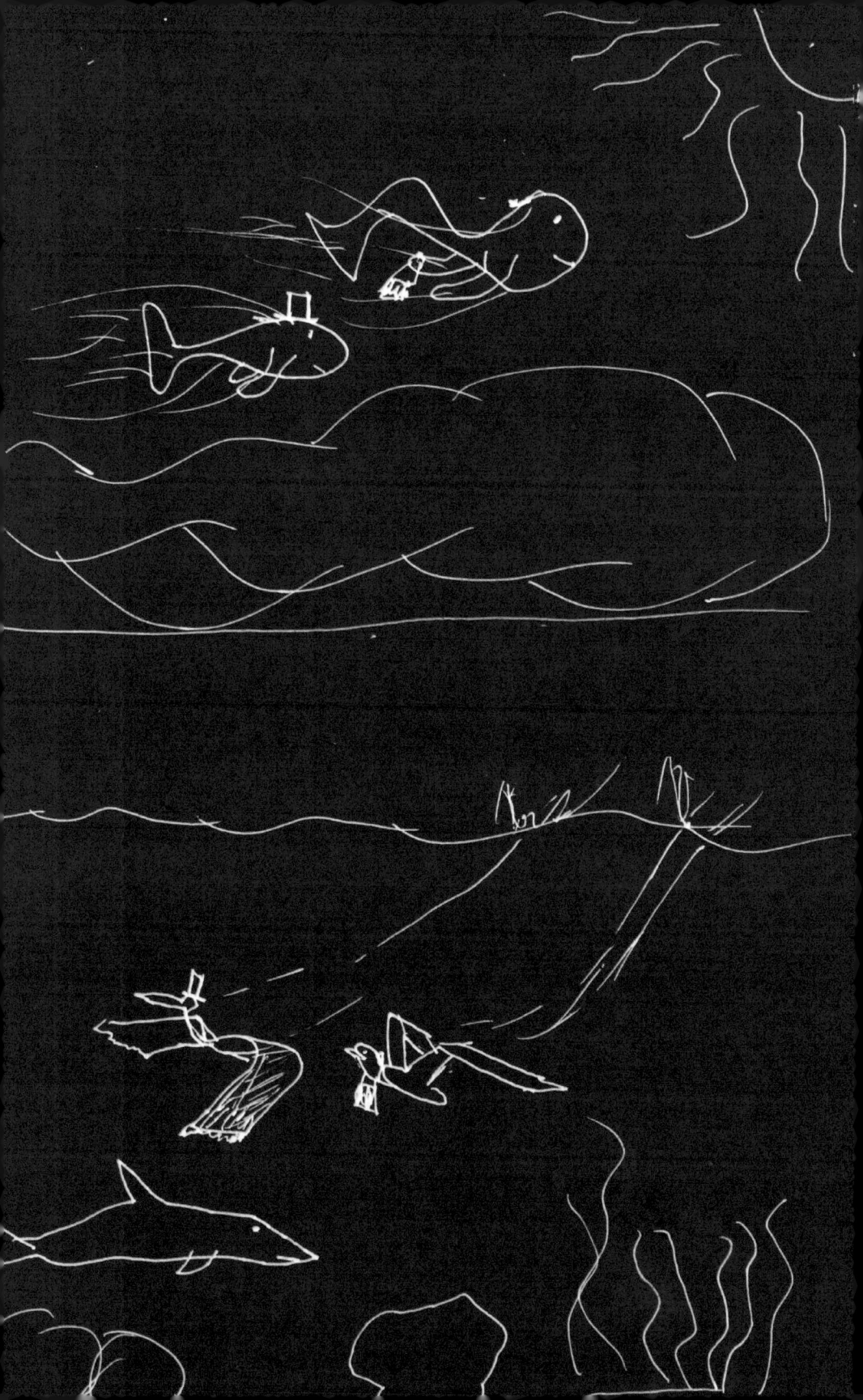

Then I turned to You And You turned to I

Then I wasnt you and I wasn't me

I turned to Us

and Us turned to We.

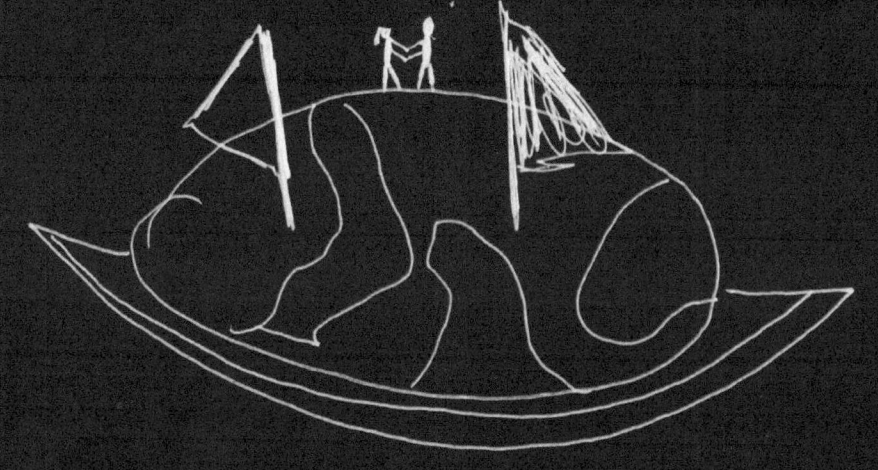

Then We broke bread with the Sun

looking right in Her eye

 and promised Her

 We'd never Ever Live a lie.

Her eyes burned a Soulfire hue of blue

 as she said,

"I do believe what you say is True."

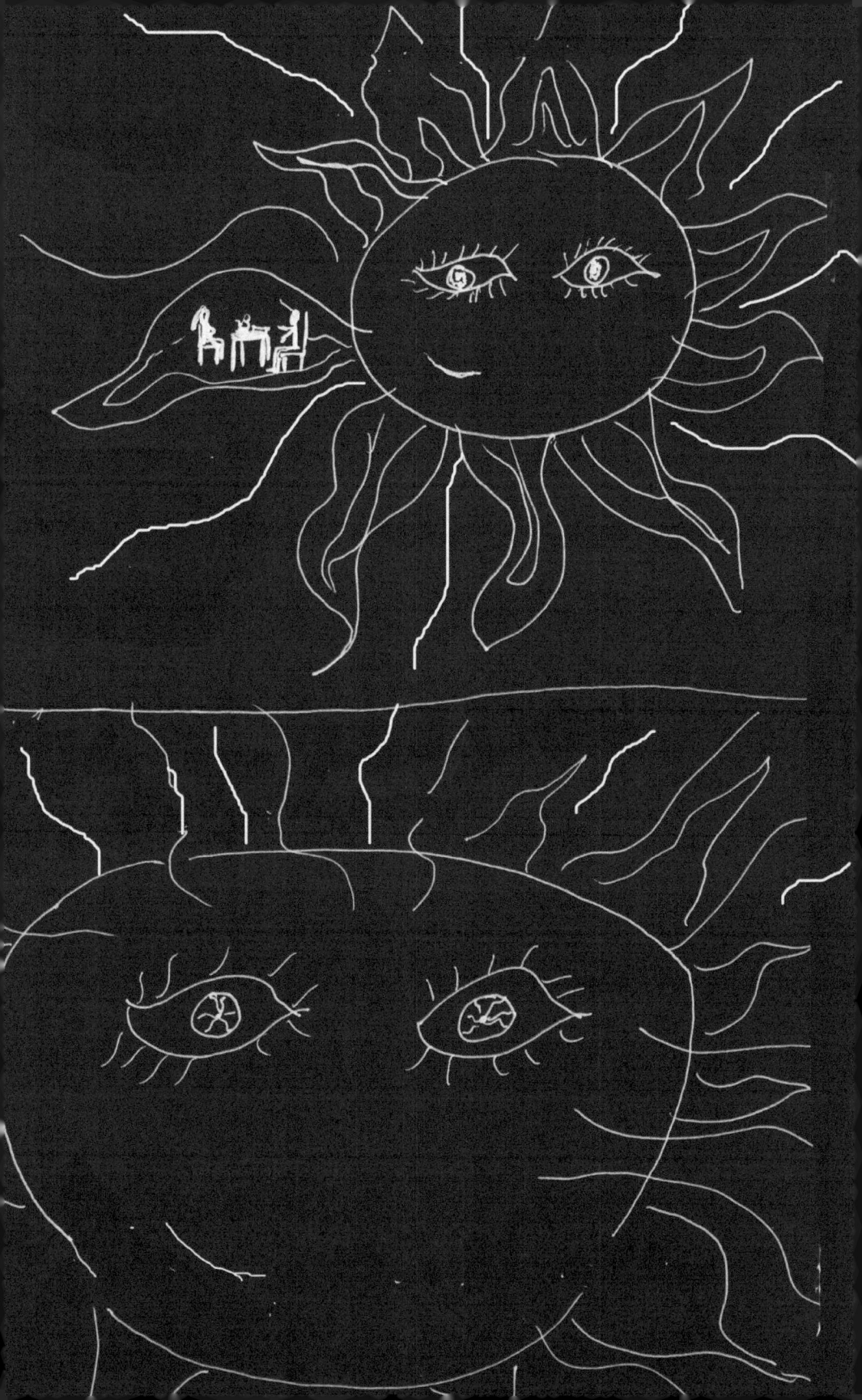

Then We flew through Universes 1 and 2 and 3

and found there were so many Universes

that they were like Drops in the Sea.

So We decided to choose a Universe

for just You and Me

so that We could Create

All of the things there could Be.

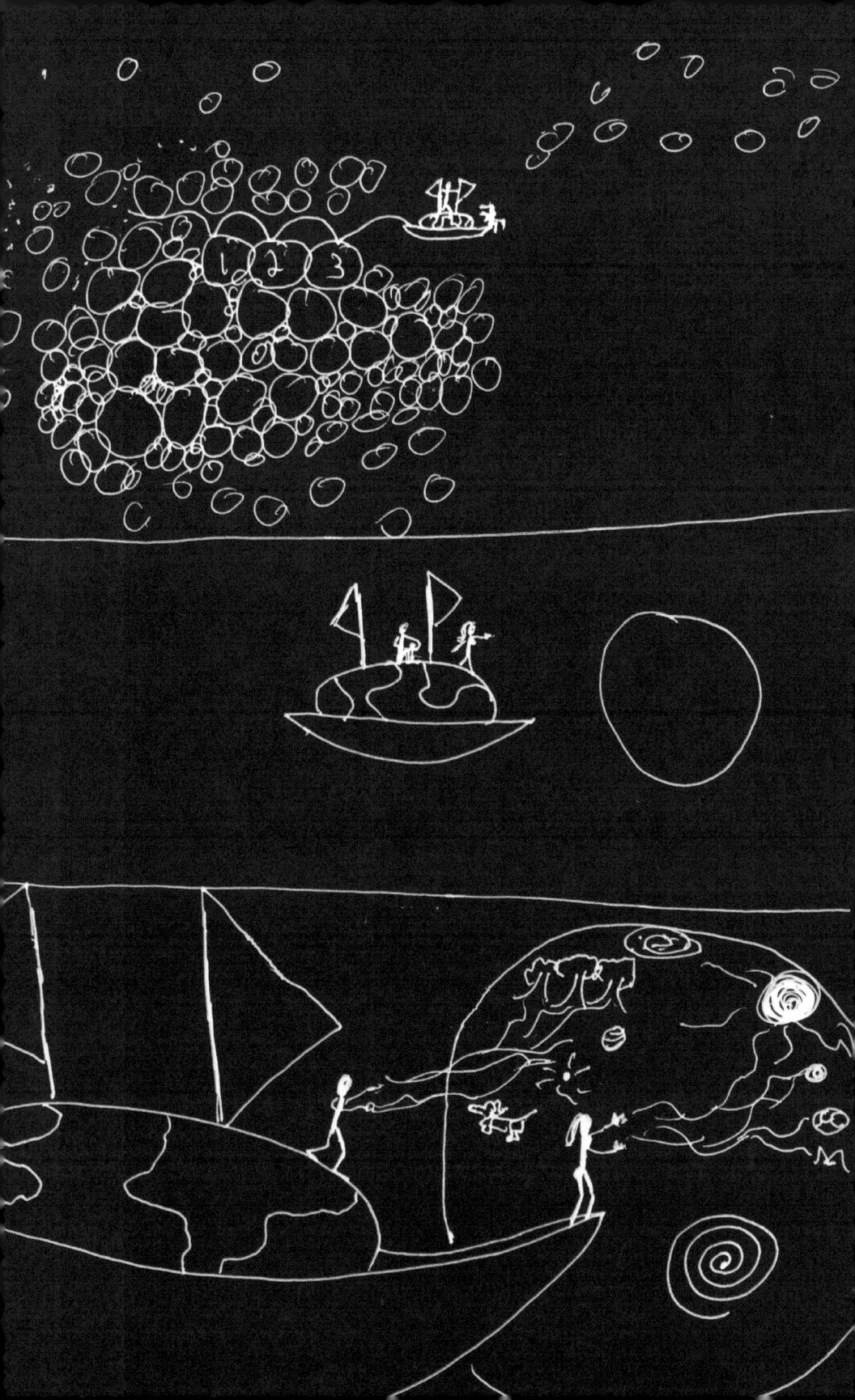

We brought down Planets

with Land and Ocean

and Gave them All their own special Star.

We Gave everything Purpose and Energy

and set Space into Motion

so Life could Discover and Love

and Create a Fate to lead it far.

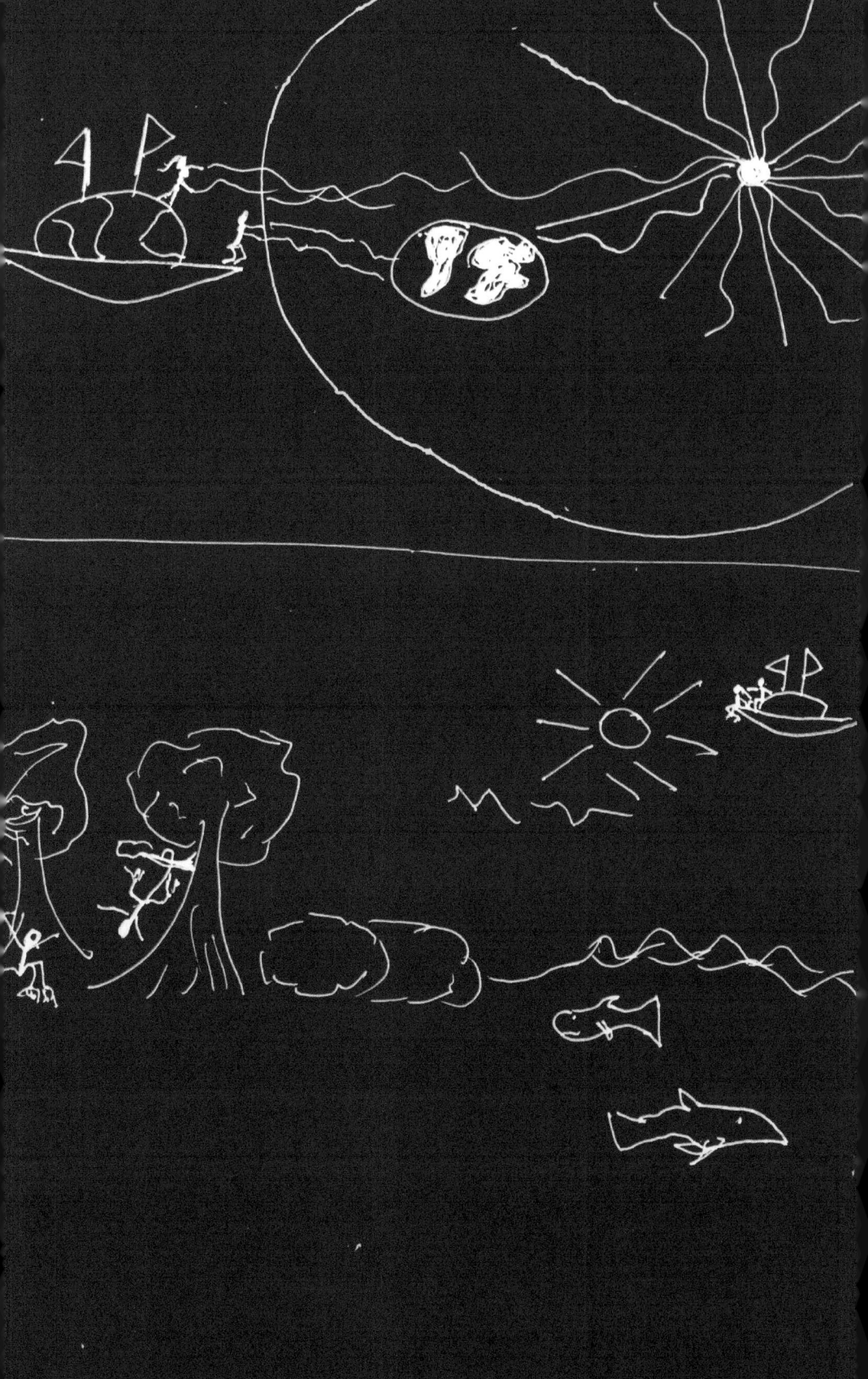

Then We waited and watched

our Universe Grow

for close to Forever.

And then You said, "Let's Play a game...

One that We can Play Together."

"What Game?" I asked.

And You answered, "Let's Play hide and go seek

through our realms of Ever."

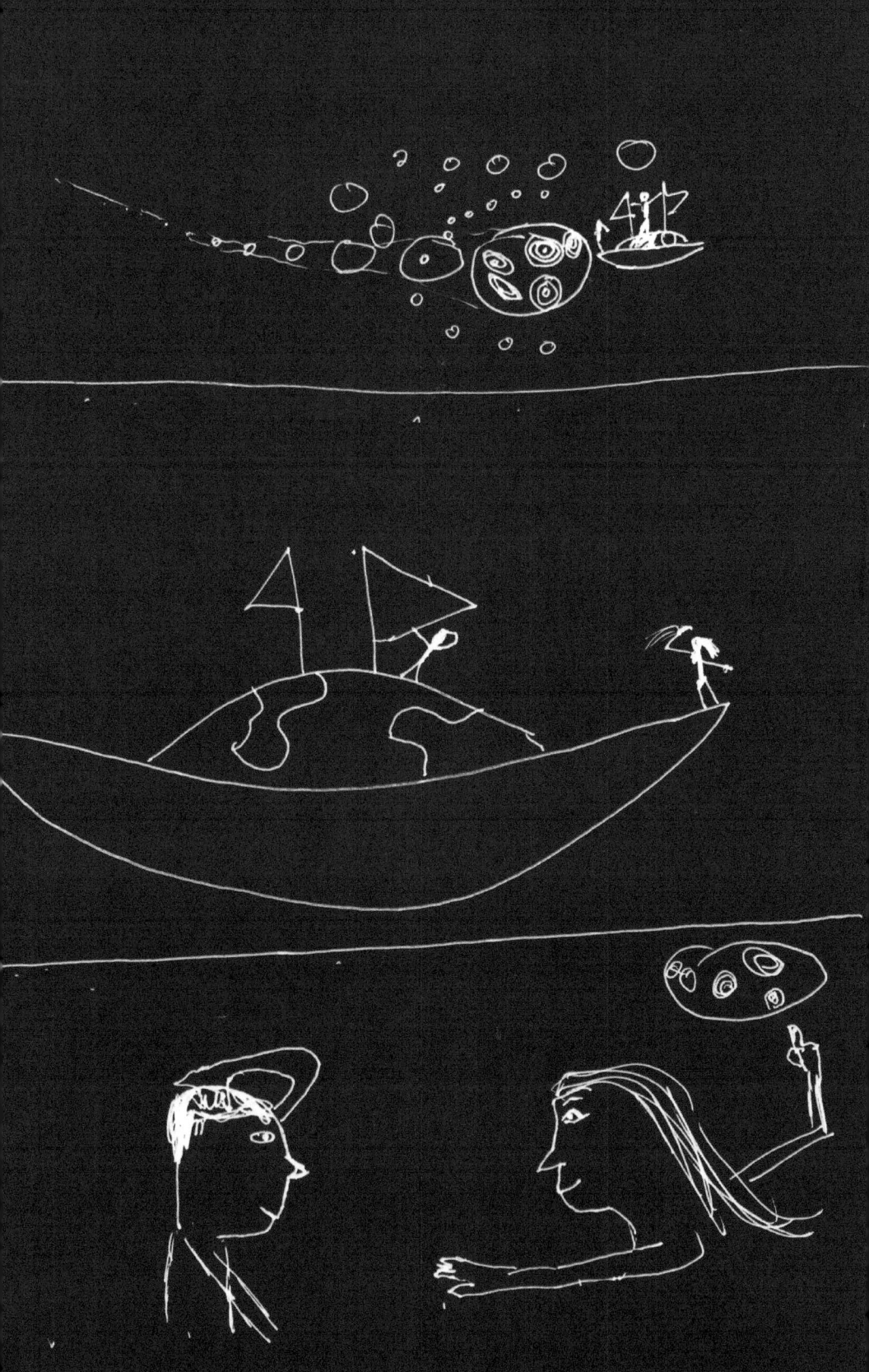

Then you told me the Dream would be hard to remember. You said no matter the places we hid we always would find ourSelves back Together some day in September.

Then You told Me
 the most important thing I could Do
Was to remember
 that only the Dream was True.

So I said, "Okay!"

And it was right then We began to Play.

First You turned back to She.

And I turned back to Me.

Then we decided the things we would Be.

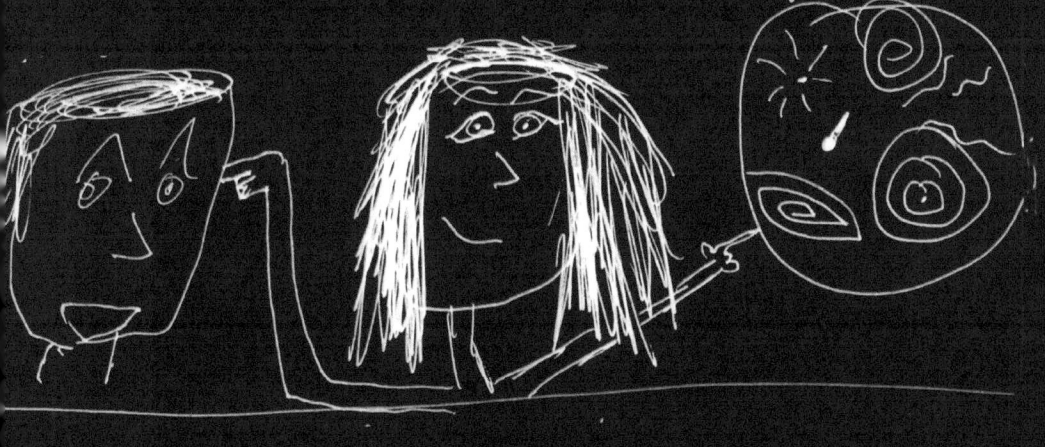

First, I was a Disease

and You were a Tree.

Then You were a war

and I was a Sea.

Then You were a Flower...

and I was a Bee.

You were a staff, a giraffe, a bath and a laugh

while I was a sock, a lock, a dock and a clock.

Then, finally, I turned to I

and You turned to you.

And it was only then

that I Knew what was True.

And every year of my Life

 I looked forward to each September.

So many I began to wonder

 If I'd find you ever... or never.

Meanwhile you had forgotten the Dream

and had been falling into the lower-being scheme.

 you worked and bought and sold

you gave up yourSelf

 and began

 to

 grow

 old.

But then I was standing on the sidewalk

watching the Sunrise and Admiring the Day,

when I saw you walking My way.

And I Knew it was You!

I said, "It's Her, it's She, my other part of Me!"

Of course I had to try and set you Free!

So I brought you over to sit by this Tree

and remind you of the Truth

of what it means to Be.

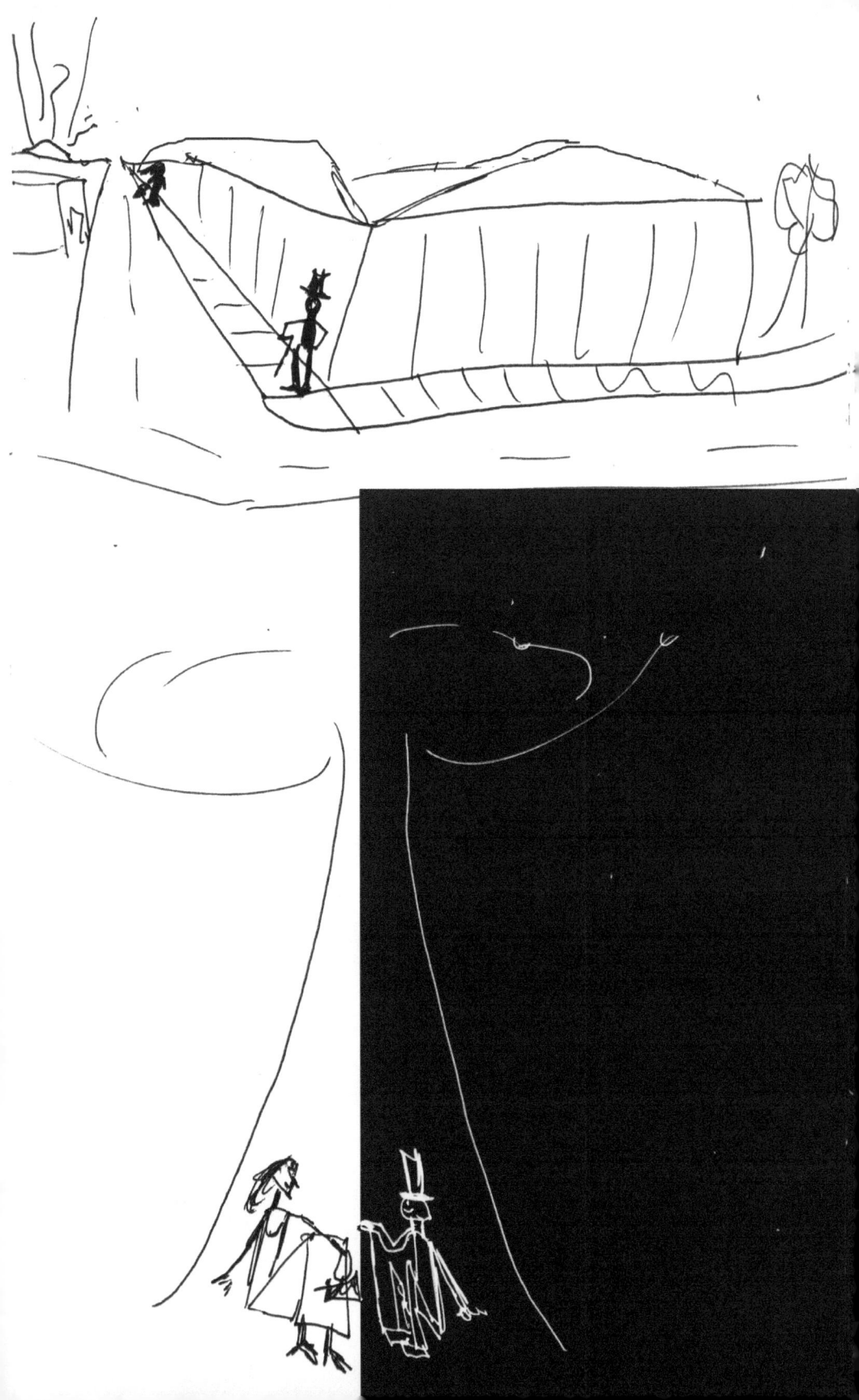

When he finished speaking
she looked at him for a long moment
and finally answered, "I'm sorry
but I don't remember one bit. And I have a life
I must get back to it."

He smiled at her and said, "That's quite alright!

Because you've been tagged

and now you're it!"

Then he hobbled off as fast as he could

yelling back behind him as he went,

"And I bet you'll be dreaming by tonight!"

She was left stunned, confused, and saddened

as she watched the strange man

head down the street and disappear out of sight.

Forgetting what she had to do with her day,

she walked slowly up the street

wearing a frown

and got back to her house

just as the sun

was going down.

Unable to think of anything

 but what the man had said,

 she went straight to her room

 to lie down in bed.

She heard the man's story

 playing over and over again

 until it was almost too much to take.

But as her Mind fell into the place

 between asleep and awake

she began to see the Dream

 unfolding through Space.

In one burst of energy her eyes flew open

glowing like a sunrise

on the first day of spring.

Her lips parted and she whispered,

"I remember...

I remember!"

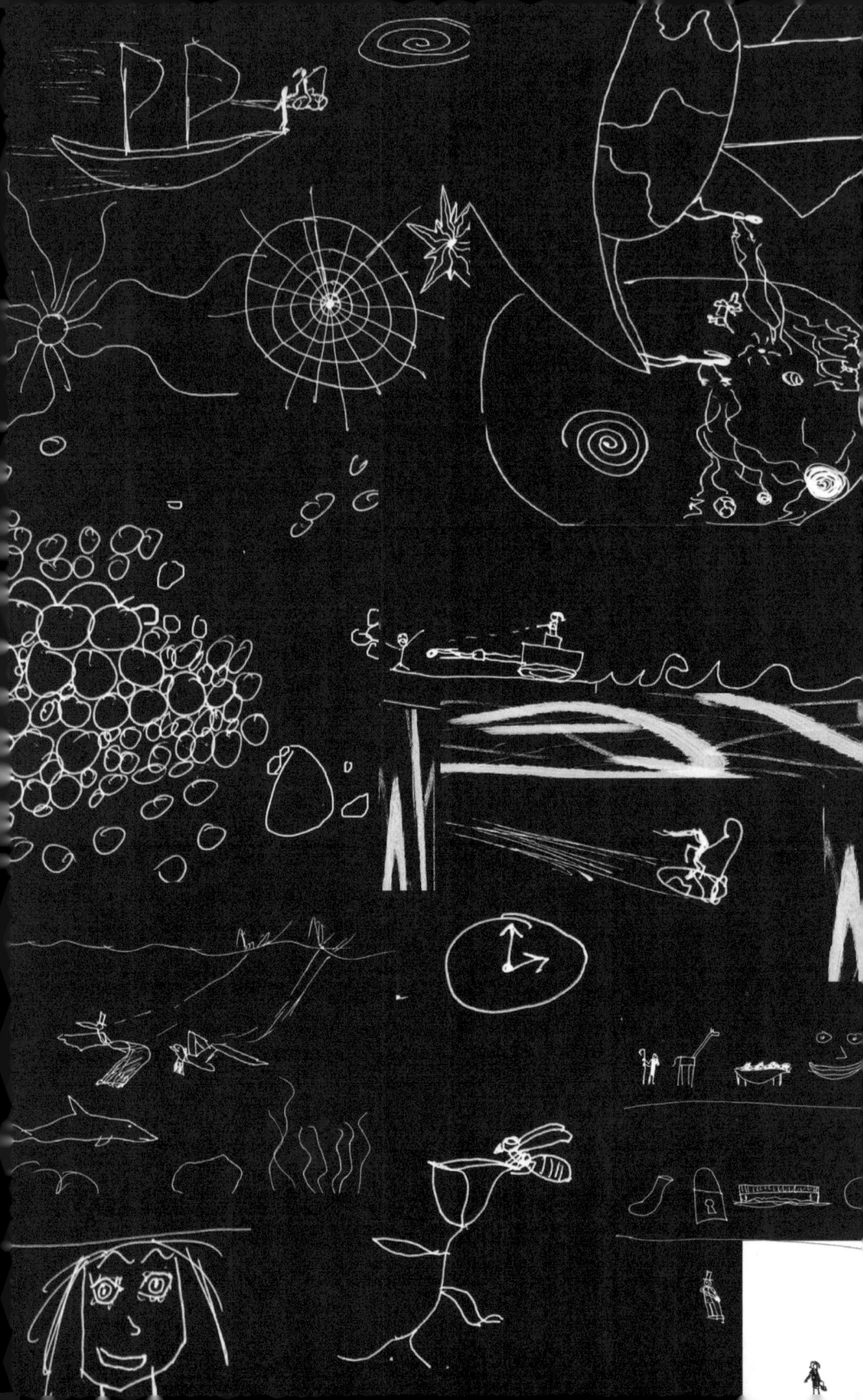

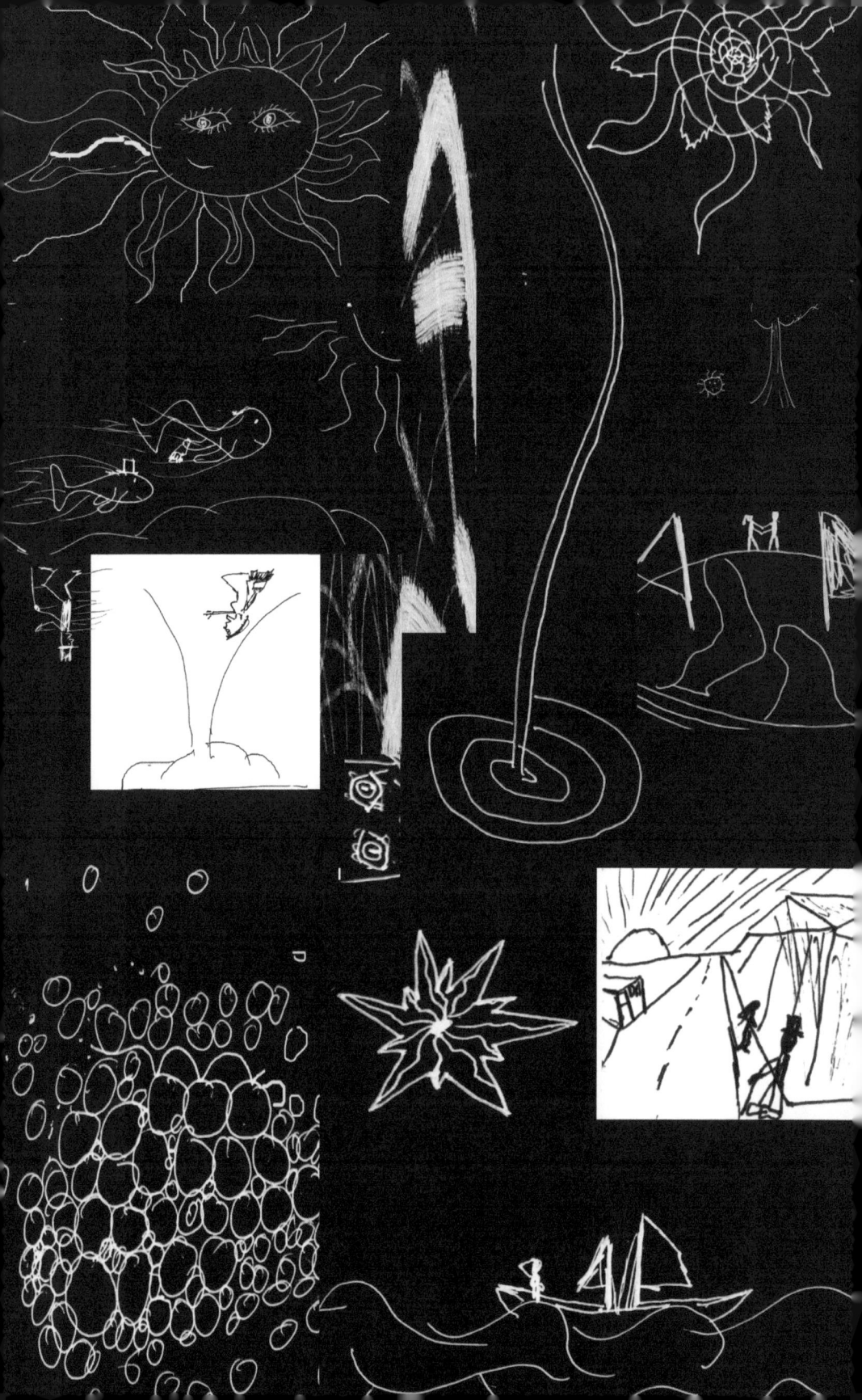

Some time later

she was standing on a corner watching the sunrise

while a man came walking down the street.

Just as the man was about to pass her

she looked at him, smiled, and said,

"Hey, I know you."

The man looked her up and down

and thought to himself for a moment.

Then he shook his head and answered,

"No, we haven't met ever."

She smiled at him

and she said,

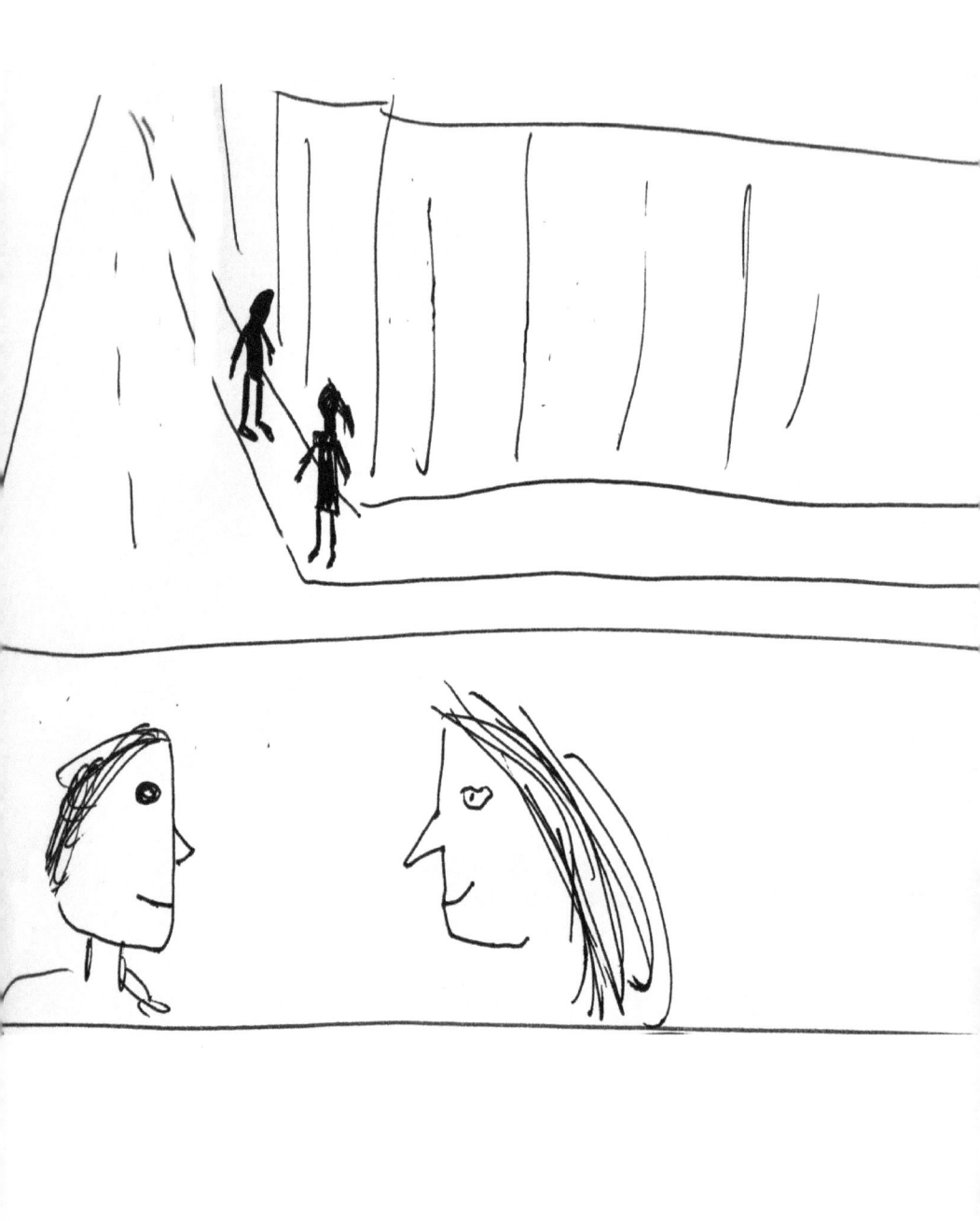

"Yes we have.

We met in a Dream

One that we made Together."

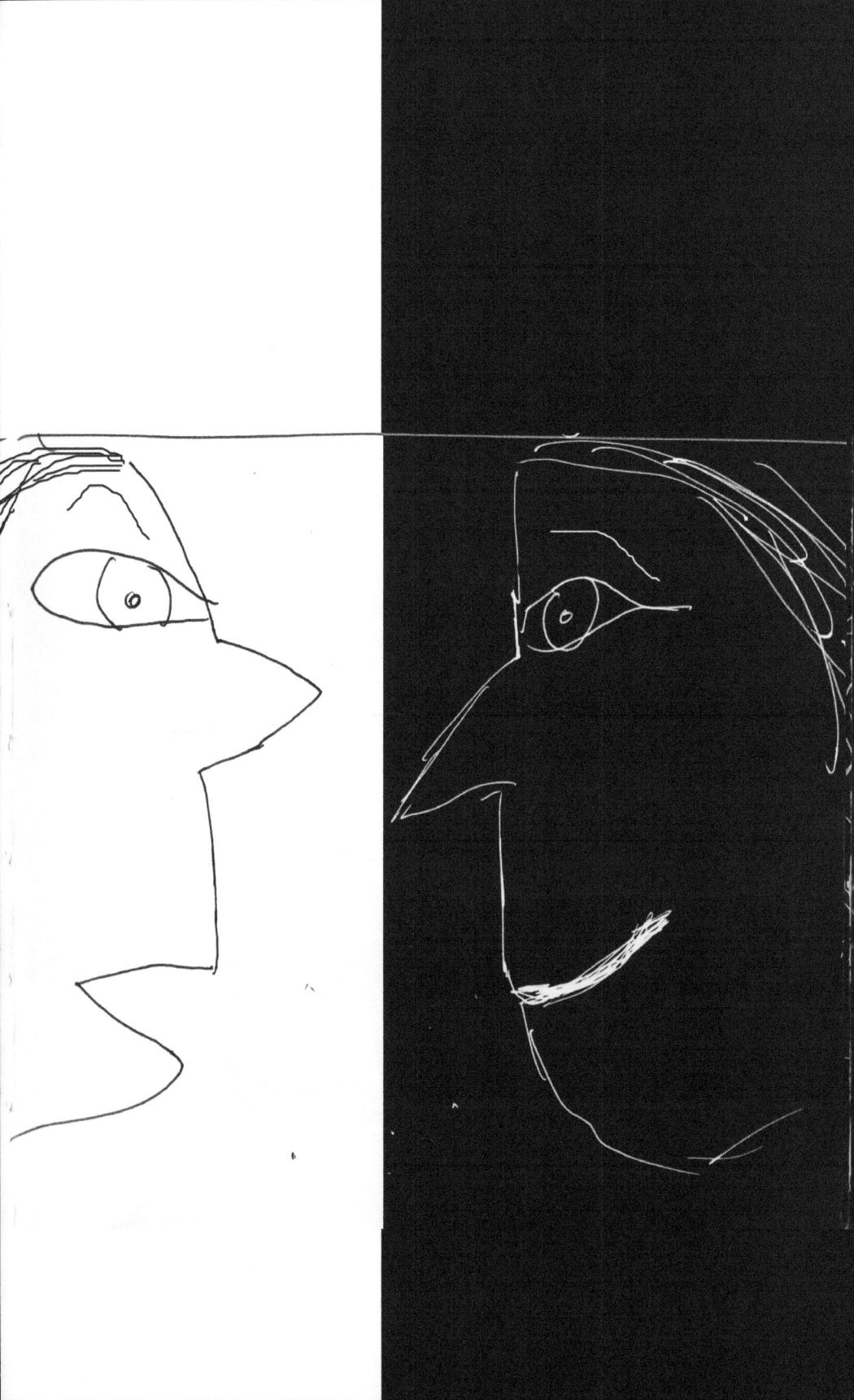

www.ingramcontent.com/pod-product-compliance
Lightning Source LLC
Chambersburg PA
CBHW040812200526
45159CB00022B/480